THE BOOK WITH THE SEVEN SEALS

By: Warnette B. Patterson

Order this book online at www.trafford.com
or email orders@trafford.com

Most Trafford titles are also available at major online book retailers.

Printed in Victoria, BC, Canada.

ISBN: 978-1-4269-3002-7

*Our mission is to efficiently provide the world's finest, most comprehensive
book publishing service, enabling every author to experience success.
To find out how to publish your book, your way, and have it available
worldwide, visit us online at www.trafford.com*

Trafford rev. 4/15/2010

 www.trafford.com

North America & international
toll-free: 1 888 232 4444 (USA & Canada)
phone: 250 383 6864 ♦ fax: 812 355 4082

I Beheld, and the same horn made war with the saints, and prevailed against them; Until the ancient of Days came, and judgment was given to the saints of the Most High: and the time came that the saints possessed the kingdom. Daniel 7: 21-22.

Warnette B. Patterson

Dedication

This Book is inspired by: my Father and Jesus; given by the Holy Spirit and birthed through me: from the Holy Spirit. It's only through the Holy Spirit am I able to hear what GOD says, as he testifies of what the Sons' purpose is for our lives. And relate that message to you.

I am eternally grateful to Jesus for all that he does for us.

I thank my Father Jehovah God Almighty, Jesus my Saviour and the Comforter: which is the Holy Ghost who remains with me; forever in me.

And secondarily: my family; Samuel, Alfreda, Consuela and Dana, My grandchildren, and Calecia, who helped with the typing; what a blessing she is to me.

To: all my friends: to every one that name the name of JESUS as Saviour: God wants you to be filled with the Holy Ghost: live and have power to perform his works, to every one that don't know Jesus: you will find him here.

PREFACE

JESUS COMMANDEDS POWER TO PERFORM

Then the eleven disciples went away into Galilee, into a mountain where Jesus had appointed them.

And when they saw him, they worshipped him: but some doubted.

And Jesus came and spake unto them, saying, "All power is given unto me in heaven and in earth.

Go ye therefore, and teach all nations, baptizing them in the name of the Father, and of the Son, and of the Holy Ghost:

Teaching them to observe all things whatsoever I have commanded you: and, lo, I am with you always, even unto the end of the world." Amen.

And he said unto them, "Go ye into all the world, and preach the gospel to every creature.

He that believeth and is baptized shall be saved; but he that believeth not shall be damned.

And these signs shall follow them that believe; In my name shall they cast out devils; they shall speak with new tongues;

They shall take up serpents; and if they drink any deadly thing it shall not hurt them; they shall lay hands on the sick and they shall recover."

For the kingdom of heaven is as a man traveling into a far country: who called his own servants, and delivered unto them his goods. Matthew: 25: 14.

INTRODUCTION

And I heard the Spirit say unto me, "Write."

So I pressed my pen to the paper and the words began to come like this:

Our Father which art in heaven Hallowed be thy name,

Thy kingdom come, Thy will be done in earth, as it is in heaven.

If any man has an ear, let him hear.

For the purpose of the law was to make you understand the holiness and righteousness of Gods character and show us his image, for us to experience and hold on to the love that have been made available to all man kind.

The law of God establishes boundaries between God and sinners, as the offenders of his righteousness.

The law lets us know the penalty of disobeying the commandments of God, It clearly define what sin derive from, by what is revealed in the Ten Commandments Of God; and God gives us the detailed outlines of the punishment for sin for the lack of obedience toward abstaining from committing sin.

When we look closely at the Ten Commandments we see clearly how God wants us to love each other and how we should be-have toward each other, as fellow human being. But by committing sin against each other, and being un-repented of the acts of sin, it brings certain death.

Because, we cannot survive without the indwelling of God's Spirit.

No one can survive with out the Spirit of God dwelling in him. We cannot survive separated from God.

But, the commandments weren't designed to give us the power to reframe from committing sin to assure our salvation before God. And regain our lost heritage.

Is the law then against the promises of God? God forbid: for **If there had been a law given which could have given life**, verily righteousness should have been by the law.

But now is Christ risen from the dead, and became the first fruits of them that slept.

For since by man came death, by man came also the resurrection of the dead.

For as in Adam all die, even so in Christ shall all be made; alive.

For he must reign (BE IN CONTROL, AND HAVE WIDE SPREAD INFLUENCE IN OUR LIVES), till he hath put all enemies under his feet.

The last enemy that shall be destroyed is death.

And so it is written, the first man Adam was made a living soul; the last Adam was made a quickening spirit.

And as we have borne the image of the earthy, we shall also bore the image of the heavenly.

But the scripture hath concluded all under sin, that the promise of faith of Jesus Christ might be given to them that believe.

But before faith came, we were kept under the law, shut up unto the faith which should afterward be revealed. (For as he is, so shall we be in this world.)

Wherefore the law was our school master to bring us unto Christ, that we might be justified by faith.

But after that faith is come, we are no longer under a school master.

For ye are all the children of God, by faith in Christ Jesus.

THERE is therefore now no condemnation to them which are in Christ Jesus, who walk not after the flesh, but after the Spirit.

For the law of the Spirit of life in Christ Jesus hath made me free from the law of sin and death.

For what the law could not do, in that it was weak through the flesh, God sending his own Son in the likeness of sinful flesh, and for sin, condemned sin in the flesh:

That the righteousness of the law, might be fulfilled in us, who walk not after the flesh, but after the Spirit.

For they that are after the flesh; do mind the things of the flesh; but they that are after the Spirit things of the Spirit.

Because the carnal minded is enmity (hostility- one as being hostile are the enemies of God) against God: for it is not subject to the law of God and neither indeed can be. (Now that is a frightening fact; that being carnal is against God; it cannot obey God, and cannot come under the bonds of the love of God, because it continually rejects the ways of God.)

So then they that are in the flesh cannot please God.

But ye are not in the flesh, but in the Spirit, if so be that the Spirit of God dwell in you. Now if any man has not the Spirit of Christ; he is none of his.

And if Christ be in you, the body is dead because sin; but the Spirit is life because of righteousness.

But if the Spirit of him that raised up Jesus from the dead dwell in you, He that raised up Christ from the dead shall also quicken (make alive) your mortal bodies by his Spirit that dwelleth in you.

Therefore, brethren, we are debtors, not of the flesh, to live after the flesh.

For if ye live after the flesh, ye shall die: but if ye through the Spirit do mortify the deeds of the body, ye shall live.

For as many as are led by the Spirit of God, they are the sons of God.

For ye have not received the spirit of bondage again to fear; but ye have received the Spirit of adoption, whereby we cry, Abba, Father.

The Spirit beareth witness with our spirit, that we are children of God:

And if children, then heirs; heirs with God, and joint heirs with Christ; if so be that we suffer with him, that we also maybe glorified together.

For I reckon that the suffering of this present time are not worthy to be compared with the glory which shall be revealed in us.

For the earnest expectation of the creature waiteth for the manifestation of the sons of God. (They are waiting for us as Ministers of the good news of the kingdom of God to demonstrate the existence, reality, and the presence and the power, of God, operating in our lives; that we might make a difference to them and bring them to salvation.

That we may demonstrate to the world, plainly, the will of God.) For the creature was made subject to vanity, (Subject to be beguiled with, worthless things, that cause emptiness, wickedness and trouble.) not willingly (seduced by the devil), but by reason of him who hath subjected the same in hope.

Chapter 1

If you are a believer in Jesus Christ, you have the God given authority and power to, heal all sickness and disease. No disease may present or manifest itself in your presence.

And the LORD said unto me, "Write: said I not to thee if thy wouldest believe, thy shouldest **see the glory** of God?

Now remember these words: (See the glory of God.)"

Now is Christ risen from the dead, and became the first fruits of them that slept.

For since by man came death, by man came also the resurrection of the dead.

For in Adam all die; even so in Christ shall all be made alive.

For he (Jesus) must reign, till he hath put all enemies under his feet. The last enemy that shall be destroyed is death.

And so it is written, the first man Adam was made a living soul; the last Adam (Jesus) was made a quickening (to cause to live, to return to life, cause to continue on in life without interruption or end) Spirit. (Therefore we receive life: by the Spirit of God.)

And as we have borne the earthy, we shall also bare the image of the heavenly.

But the scripture hath concluded all under sin, that the promise by faith of Jesus Christ might be given to them that believe.

But before faith came, we were under the law, shut up unto the faith which should afterward be revealed. (For as Jesus is so shall we be in this world.)

Wherefore the law was our school master to bring us unto Christ, that we might be justified (Be made right to receive the promise.) by faith.

But after faith (Our hearts are renewed love and trust in God will return.) is come, we are no longer under a school master.

For ye are all the children of God, by faith, in Jesus Christ.

For as many of you have put on Christ, are Christ's.

For there is neither Jew nor Greek, there is neither bond nor free, there is neither male nor female: for ye are all one in Christ Jesus.

And if ye be Christ's then are ye Abraham's seed, and heirs according to the promise.

Now I say the heir, as long as he is a child, differeth nothing from the servant, though he be lord of all;

But is under tutors and governors until the time appointed of the Father.

Even so we, when we were children were under bondage under the elements of the world.

But when the fullness of time was come, God sent forth his Son, made of a woman, made under the law.

To redeem them that was under the law, that we might receive the adoption of sons.

And because ye are sons, God hath sent forth the Spirit of his Son into our hearts, crying, Abba, Father.

Wherefore thou art no more a servant, but a son; and if a son, then an heir of God through Jesus Christ.

Wherefore he saith, when he ascended upon high, he led captivity (Jesus depopulated, all the prisoners of the devil as many that wants to be released from the bondage of sickness and death through sin., Jesus made a way for you to be released: simply by receiving him as Lord and Saviour.) captive, and gave gifts to men.

These gifts are what the Lord are bringing to light.

"But ye shall receive power, after that the Holy Ghost is come upon you: and ye shall be witnesses unto me both in Jerusalem, and Judea, and in Samaria and in the uttermost part of the world."

And when he had spoken these things, while they beheld, he was taken up; and a cloud received him out of their sight.

Now that he ascended, what is it but that he also descended first into the lower parts of the earth.

Matthews Gospel explains it this way.

And they crucified him, and parted his garments, casting lots: that it might be fulfilled which was spoken by the prophet,

They parted my garments among them, and upon my vesture did they cast lots.

And sitting down they watched him there;

And set over his head his accusation written,

(In those days when you were put to death for a crime they would write the crime on a slate, and nail it above your head on the cross that you died on.

On Jesus' slate they wrote :) THIS IS JESUS THE KING OF THE JEWS.

Luke's Gospel explains it this way:

And Pilate wrote a title, and put it on the cross. And the writing was, JESUS OF NAZARETH THE KING OF THE JEWS. This title then read many of the Jews; for the place where Jesus was crucified was nigh to the city: it was written in Hebrew, and Greek, and Latin.

Then said the chief priests of the Jews to Pilate, "Write not, The King of the Jews; but he said, "I am King of the Jews."

Pilate answered, "What I have written I have written."

Matthew 27:38-54:

There were two thieves crucified with him, one on the right hand, and the other on the left.

And they that passed by reviled him, wagging theirs heads. And saying, "Thou that destroyest the temple, and buildest it in three days, save thyself. If thou be the Son of God, come down from the cross."

Like wise the chief priest mocking him, with the scribes and elders, said,

"He saved others; himself he cannot save. If he be the King of Israel, let him come down from the cross, and we will believe him.

He trusted in God; let him deliver him now, if he will have him; for he said I am the Son of God."

The account of Luke 23: 39:

And one male factor which hanged railed on him, saying, "If thy be Christ save thy self and us."

But the other answering rebuked him, saying, "Doest thy fear God, seeing thou art in the same condemnation?

And we indeed justly; for we received the due reward of our deeds: but this man has done nothing amiss."

And he said unto Jesus, "Lord remember me when thou comest into thy kingdom."

And Jesus said unto him, "Verily I say unto thee, Today shalt thou be with me in paradise."

Matthew 27:45- 54:

Now from the sixth hour there was darkness over all the land unto the ninth hour. And about the ninth hour Jesus cried with a loud voice, saying, "Eli, Eli, la'ma sa bach'tha-ni? That is to say, My God, my God,

why hath thou forsaken me?" (For the first time in all creation Jesus knew what is was like to be separated from the presence of his Father, (As soon as Jesus cried out to God: God was there, (Isaiah 50: 3 reads) I clothed the heavens with blackness, and I made sackcloth their covering. (He put them in a temporary repentant state, that they would not be destroyed. Because it is impossible for God not to judge sin, he is holy and righteous, and no sinner can stand in his presence and not be consumed.) He came down riding on the wings of the wind. Psalm18:10.

He bowed the heavens also, and came down: and darkness was under his feet.

And he rode upon the cherub, and did fly, upon the wings of the wind.

He made darkness his secret place; his pavilion round about him were dark waters and thick clouds of the skies.)

Some of them that stood there, when they heard that, said, "This man calleth for Elias."

And straight way one of them ran and took a sponge, filled with vinegar, and put it on a reed, and gave him to drink.

The rest said, "Let be, let us see whether Elias will come to save him."

Jesus, when he had cried again with a loud voice, yield up the ghost.

And behold the veil of the temple was rent in twain from the top to the bottom; and the earth did quake, and the rocks rent; Matthew 27: 51

At the brightness that was before him his thick clouds passed, hail stones and coals of fire. Psalm 18:13

The LORD also thundered in the heavens, and the Highest gave his voice; hail stones and coals of fire.

Yea he sent out his arrows, and scattered them; and he shot out lightning's, and discomfited them. Psalm 18:14)

He (God) came riding on the wings of the wind.

And the graves were opened; and many bodies of the saints which slept arose.

And came out of the graves after his resurrection, and went into the holy city, and appeared unto many.

Now the centurion, and they that were with him, watching Jesus, and those things that were done, they feared greatly, saying, "Truly this was the Son of God."

He that descended is the same also that ascended up far above the heavens, that he might fulfill all things.

And he gave some, apostles; and some, prophets; and some evangelists; and some pastors and teachers;

For the perfecting of the saints; for the work of the ministry, for the edifying of the body of Christ:

That we henceforth be no more children , tossed to and fro, and carried about with every wind of doctrine, by the sleight of men, and cunning craftiness, whereby they lay in weight to deceive;

But speaking the truth in love may grow up into him in all things which is the head, even Christ:

From whom all the body fitly joined together and compacted by that which every joint supplieth, according to the effectual working in the measure of every part, Maketh increase of the body unto the edifying itself in love.

And to know the Love of Christ, which passeth knowledge, that ye might be filled with the fullness of God.

Now unto him that is able to do exceeding abundantly above all that we ask or think, according to the power that worketh in us.

Chapter 2

Now we receive the, not the spirit of the world, but the Spirit which is of God; that we might know the things that are freely given to us of God.

We must get to the place where we can be perfected by the Holy Ghost, and receive the promise of power.

Many Christians do not know what is freely given to them of Christ. The powers that are freely given are explained in Revelation 5:1-14;
The Book Of The Seven Seals, which is Jesus' kingdom and dominion which only he is worthy to receive and restoration of power for mankind.

The seven seals releases the seven Spirits of God, To be received by Jesus, the LAMB which was slain, to also give power unto men to carry out our Father's will for our lives here on earth. (The Lord said unto me; "Write.")
Again I put my pen to the paper;

I beheld, and the same horn made war with the saints and prevailed against them;

Until the Ancient of Days came, and judgment was given to the saints of the Most High; and the time came that the saints possessed the kingdom. (The kingdom of God must come right here on earth.)

When Jesus began to preach, "Repent the kingdom of heaven is at hand, Believe the Gospel."

Jesus wants us to ask for forgiveness and in turn for give all that offend you even your enemies; and turn from all the wickedness that we are doing.

We have to make up our minds to believe and receive the good news of the Gospel of Jesus Christ.

The Good News (gospel) reports the truth about restoration, and it informs you about what has happened, is happening or what is expected to happen.

The Gospel (Good News) comes from a reliable source, Jesus Christ himself and is sealed with the Holy Ghost of the promise, it is the Holy Ghost that will lead us to the truth. He is the divine teacher, what ever he hears the Father say that is what he will report, and that alone.

The reason that it is reported through the Holy Ghost is because he is the truth and because you must get to the point where you can believe the truth, the Gospel.

He wants us to study Jesus' every movement Hear every thing that he said, you must be consumed with

him (sup) take him in, he in you, you in them, becoming the reflection of the mirrored image, of Jesus, that as we have seen him do we shall do also, and greater things we will be able to do.

Sup with him, consume every word, every promise, Examine the Word, take it in, live it believe it breath it , become the outcome of the promised word.

You are the results that the Holy Spirit will move through.

Jesus came performing the results that he intended for us to achieve.

He showed us how to take back what was stolen from us. And he restored all rights to us by dying for our sins, sealing it with his, own blood.

Through a lie it (mans' dominion) was taken away, by disobeying a direct command from God. (mankind let it be taken away).

And through the truth, and acting with belief, we can take it back. (We take it back).

When we believe the Gospel we will see the kingdom of God in power. We'll see it operating in our lives, and in the lives of others, through us, not with an outward show, but the results of God's kingship in us, with astounding miracles of every kind.

Jesus sealed the promise; which is the New Testament, with a better Covenant, with his own blood., and he didn't leave us powerless or comfortless,

because he sent the Holy Spirit to remain in us, and to be here for us, operating in our lives, on our behalf, to strengthen us and guide us into all truth:

The Holy Spirit gives us power to reframe from all sins, he strengthens our inner man that; unless that inner man is strengthened and nourished with the truth, by the Holy Spirit, life cease, we must be recharged by the Spirit of God to live.

By the Holy Spirit alone we are able to perform the wonderful works of God, to gain a pre-decided victory.

Because everyone that breaks the commands of God are in sin, and rendered powerless.

The Holy Spirit brings the reproducing power that is able to reconnect us back to the Father, through the Spirit, that we might be recharged and put on Jesus Christ.

Jesus said, "Than they all may be one; as thou, Father, art in me, and I in thee, that they also may be one in us, (You cannot be connected to the Father and the Son, and be filled with his Spirit and remain powerless, you are connected to the power.) that the world may believe that thou hast sent me.

And the glory (power) which thou hast given me, I have given them; that they may be one, even as we are one:

I in them; and thou in me, that they may be one, even as we are one: I in them; and thou in me, that they may be perfect in one; and that the world may know that thou hast sent me, and hast loved them, as thou hast loved me.

(Jesus has promised us, that we are in covenant with him, the Father and the Holy Spirit, when we accept the Atonement.)

But as it is written, Eye hath not seen, nor ear heard, neither have entered into the heart of man, the things which God hath prepared for them that love him.

But God hath revealed them unto us by his Spirit; for the Spirit searcheth all things, yea, the deep things of God.

Chapter 3

We must reconnect and be recharged.

We were alienated from our Father: who is holy and righteous. And because he is holy, he cannot look upon sin without judgment, and that is because of his holiness and righteousness, the ultimate of perfection.

But make no mistake about it, God loves you, and cares for you, so much so, he put into motion the plan of reconciliation, his very own act of love toward us; to reconcile us to himself. (It is the only way we can be recharged and reconnected to him, without being judged for our sins, Jesus covered our sin long enough for us to receive the salvation plan that we may repent and be saved.

The Bible clearly states that: "What shall we say of these things?"

If God be for us, who can be against us?

He that spared not his own Son, but delivered him up for us all, how shall he not with him also freely give us all things?

Every thing that is of God is in Christ Jesus, He is the love of God.

(That is why Jesus said, "Have I been so long time with you, and yet hast thou not known me, Philip? He that hast seen me has seen the Father; and how sayest thou then, shew us the Father.

Believest thou not that I am in the Father, and the Father in me? The words that I speak unto you I speak not of my self: but the Father that dwelleth in me, he doeth the works.)

Jesus came in the power of the love of God to present that love and mercy to us.

And he allowed Jesus to taste sin for us all.

But! It is impossible for God not to judge sin.

Because, He is holy and righteous.

However he has worked it out so that we can come to him through Jesus, making it possible to receive salvation.

When we are in sin, we are alienated from God, he is affected, because he loves us and wants to save us.

We are affected because we have turned our backs to him, and have learned to love and worship the things that cannot save us.

Therefore we cannot receive the love that he has for us because we cannot trust the love that he has shown to us through His Son, Jesus.

Therefore we can't be one, because sin has come between us, and it keeps us from receiving the truth

and making the right decision to make that divine connection back to God.

(Our refusal to accept correction and directions, allows rebellion to take hold of us.)

Even to the point that it allows the thief to steal the very word that is able to connect us back to the Father.

So how can we go to God without being judged? We can't, but Jesus: he is the mediator, between God and man.

The Bible says:

He that spared not his own Son, but delivered him up for us all, how shall he not with him also freely give us all things?

We are alienated from God because of the lies from the wicked one, and we are affected by the tares that were sown among the wheat in the field, while the men slept.

Then kingdom of heaven is likened unto a man which sowed good seed in his field.

Jesus came preaching "Repent" the kingdom of heaven is at hand, believe the Gospel.

He showed us the kingdom by commissioning the twelve disciples to go and proclaim the Good News. Of the gospel Matthew 10: 7-10:

He said, "As you go, preach, saying the kingdom of heaven is at hand. Heal the sick, (lay hands on them

and they shall recover.) cleanse the lepers, (give them a command, to go and wash) raise the dead, (not bury them) cast out devils (command them to go, do not fellowship with them): freely you have received freely give. Provide neither gold, nor silver, nor brass in your purses, nor script for your journey, neither two coats, neither shoes, nor yet staves: for the workman is worthy of his meat. (Jesus commanded them to take nothing for their journey, because he wanted to build up their level of trust in him.")

This is the good seed that was sown in the fields.

But while men slept, his enemy came and sowed tares among the wheat and went his way. (Tares are grass, that from the beginning look like wheat, but after it has grown, it is obviously not the same. The tare is put in the field as a distraction, it's there to chock out the word, it is irreducible, it cannot let go of pride to be reduced and re-conformed to a desired vessel, it is deadly poison.

You know like when you were in your sin, and God became the Potter and you were the clay, Well the enemy put a undesired element into the field of wheat, a place where you are suppose to get your necessary food and get saved grow and become a vessel fit for the master's use.

But instead the enemy changed the word of God and tried to make it of none affect; by telling you that you have to pay a debt that you do not owe.

He's not able to nourish you and help you come to your full potential, because he is void of love, power,

and life and he do not have the substance to sustain life. If you eat from this tare it will eventually kill you because it is deadly poison.)

Matthew 12: 27-30:

So the servants of the householder came and said unto him, "Sir, didst not thou sow good seed in thy field? From whence then hath these tares?"

He said unto him, "An enemy hath done this."

The servant said unto him, "Wilt thou then that we go and gather them up?"

But he said, "Nay: lest while ye gather up the tares, ye root up the wheat also with them.

Let both grow together until the harvest: and in the time of harvest I will say to the reapers, Gather ye first the tares, and bind them first in bundles to burn them: but gather the wheat into my barn."

We are alienated because of the lies from the wicked one, and we are affected by the tares that the enemy has planted, in the fields, that say they are Gods' but are not, they have been sown there by the enemy.

Jesus said, many will say in that day, "Have I not cast out devils in thy name and done many miracles," He said, "I will answer and say; Get away from me, I never knew you."

He said, "And when the king came in and to see the guest, he saw there a man which had not on a wedding Garment:

And he said unto him, "Friend, how comest thou in hither not having a wedding garment?" And he was speechless. Because he had not put on the likeness

of Jesus through the Spirit; which is love, joy, peace, longsuffering, gentleness, goodness, faith, meekness and temperance.

Then said the king to the servants, "Bind him hand and foot, and take him away, and cast him into outer darkness; there shall be weeping gnashing of teeth.

For many are called but few are chosen."

The Bible says that Jesus died for the sin of the whole world, and the price that he paid was his life for ours, and he sealed the covenant with his own blood.

He gave his life for ours the debt is completely Paid In Full.

We are now entitled to the benefits of the atonement, by our confession of sin, repenting and turning completely away from the elements of sin, then and only then can restoration begin.

The devil wants you to believe that you owe a debt that has already been paid; he wants you to think that, that debt has to be paid by your death.

Because Jesus is life and the only way to life, is we must change our minds from death to life. (It's real simple to me.)

Jesus says: "I am the way the truth and the life, no man cometh unto the Father but by me. You can't usher greet the saints, work as a deacon, pastor or even a minister, enough to cleanse yourselves from sin, Jesus is the only way. Jesus said;

"The thief cometh not but for to steal and to kill and to destroy.

I am come that they might have life, and have it more abundantly.

I am the good shepherd; The good shepherd giveth his life for the sheep." So if you are his sheep he gave his life for you.

We are guilty of sinning no matter how good we think we are.

No matter how we have become self-righteous; no matter how many good deeds we do.

If we do not receive Jesus as Saviour and Lord we are with out hope, we don't have salvation or life, and our righteousness is as filthy rags.

We must admit before God that we are guilty of sin, the remorsefulness of having done something wrong, by confession, shows that you are remorseful and willing to bear the responsibilities for your actions, and that you do accept the penalty and punishment of the judgment that was handed down.

Actually an offence has been committed against love, and it makes you answerable to the seat of judgment to bear the penalty, for your sins.

The judgment has been preset, and the guilty plea has been accepted, which is the penalty of death.

But wait!! don't die! Wait!! Please wait! Don't die. JESUS TOOK YOUR PLACE!! HE DIED IN YOUR STEAD: YOU CAN LIVE!! WHEN YOU REPENT.

You have been redeemed from the hands of the enemy and you are free to go!!

You should have paid with your life, and your soul should have ended up in hell, but JESUS took your place, he has cleansed you from all sin and all unrighteousness, so that you can turn from sin, and be free to worship and praise God, and be reconnected to the Father through JESUS Christ his SON.

To re-establish your relationship or to establish a new relationship; say, "Lord Jesus please forgive me for my sin, because I am a sinner, cleanse me from all unrighteousness, and all my transgression where in I have transgressed against you, come into my heart I am so ready to receive you, I need a Saviour and I want you to be my Saviour, I cannot keep myself therefore I am asking you to keep tight hold of my heart that I sin no more against you, toward others.

The Bible says if you confess your sin he is just to forgive you your sin. What say it the word is nigh thee in thy heart and in thy mouth, that if you will confess the Lord Jesus (BELIEVE THAT HE IS) and believe that God has raised him from the dead, you shall be saved and I pray that you will receive the Holy Spirit. Simply ask him to come in and make his abode, and he will be in you.

Please obey his loving kindness.

Chapter 4

Is the law then against the promise of God? God forbid: for if there had been a law given which could haven given life, righteousness should have been by the law.

But righteousness came by Jesus Christ to reconstruct our temples.

We are made in the image of God after his likeness.

When sin entered in the world our temples laid in ruins, set for demolition.

Our character has been damaged, not destroyed, our natural beauty has begun to fade by the strain of sin, and consequently our mistrust in the love that GOD has for us is doubted and has been abated. And the judgment of sin fell on us all, because of disobedience.

One of the biggest mistakes we make is; believing that our sin is hidden, the realization is that there is nothing that God doesn't see; nothing or any one is hidden from the presence or sight of God.

The enemy would have you believe that the exposure of sin is disastrous, and there is gross sin; however all sin should be confessed, because that is what the Bible says.

The enemy will have you to believe that the confession of sins brings shame. Remember that is from the devil.

There is no sin committed that is completely hidden from God partly or otherwise.

God knows, and so does someone else, but most of all so does everyone else. But most of all you know, and to think that it is absolutely hidden is foolish to think.

For the Bible says that the word of God is quick and powerful and sharper than any two-edged sword, piercing even to the dividing asunder of soul and spirit, and of the joints and marrow, and is a discerner of the thoughts and intents of the heart.

Neither is there any creature that is not manifested in his sight; but all things are naked and open unto the eyes of him whom we have to do.

He revealeth the deep and secret things; (he tell it to whom ever he pleases) he knoweth what is in the darkness, and light dwelleth with him.

Do as Jesus did, he despised the shame.

So repent and turn from your sins, and purpose in your heart never to sin again. And then you will be able to despise the shame, because deliverance will manifest itself in you.

Shame is a painful emotion brought on by guilt.

The thought of exposing sin causes embarrassment, and the though of our sin being exposed brings disgraced and causes fear, and fear is subject to dishonor, depression and eventually worthlessness, depending on the magnitude of the act, It is all brought on by guilt.

It is the thought to render you useless by God but it is not the truth.

Guilt is a painful emotion of disgrace, it should produce remorsefulness to confession, but some times it doesn't.

That is what makes many people destroy their lives, because of the guilt that it renders, it can rob you of your dignity and self-esteem, even your life.

But confession strengthens and destroys these spirits. I'm not saying there won't be repercussion from your actions but I am saying the God will be with you through them and he will see you through it all.

Confessions save you from destroying yourself, and even others, Confession is the solution that destroys fear, which activates anger.

Jesus despise the shame, he was guiltless of sin, yet shame came to him to try to persuade him to come down from the cross, to abandon Gods' plan for mankind, to abandon the suffering, to abandon the love that he has toward us, for his sake.

You see fear and shame are partners, they work together to bring dishonor, and condemnation, rendering you unfit and unworthy to receive the promises of God.

Jesus was straight forward he accepted the humiliation, knowing that there was a greater reward; not for himself alone, but for as many as would receive him as Saviour and Lord.

Isaiah 50:6,7:
I gave my back to the smiters, and my cheeks to them that plucked off the hair; I hid not my face from shame and spitting. Is the prophesy that Isaiah prophesied about Jesus.

If you can receive it as the thoughts of Jesus: "For the LORD will help me; therefore shall I not be confounded; therefore I have set my face like a flint, and I know I shall not be ashamed.

He is near that justifieth me; who will contend with me? Let us stand together: who is my adversary? Let him come near to me.

Behold, the LORD GOD will help me; who is he that shall condemn me? Lo he shall wax old as a garment; the moth shall eat them up."

Surely he hath born our griefs and carried our sorrows: Yet we did esteem him strickened and smitten of God, and afflicted.

But he was wounded for our transgressions, he was bruised for our iniquities: the chastisement of our peace was upon him: and with his stripes we are healed.

Chapter 5

And he said unto me: "Write:"
And so I began to write:

The LORD is my shepherd; I shall not want.
(But my God shall supply all your need according to his riches in glory by Christ Jesus. Philippians 4:19).
He maketh me to lie down in green pastures. (Psalm 23:2a)
(Peace I leave with you, my peace I give unto you: not as the world giveth, give I unto you. Let not your heart be troubled neither let it be afraid. John 14:27.
These things have I spoken unto you, that in me ye might have peace. In the world ye shall have tribulation: be of good cheer I have over come the world. John 16:33: that means that what ever goes on in the world should not affect you) he leadeth me besides the still waters. Psalm 23: 2b. (And the peace of God, which passeth understanding, shall keep your hearts and minds through Christ Jesus. Philippians 4:7)

He restoreth my soul, Psalm 23: 3a. (For I have received of the Lord that which I also delivered unto you, That the Lord Jesus the same night in which he was betrayed took bread:

And when he had given thanks, he break it, and said, Take, eat: this is my body which is broken for you: this do ye in remembrance of me.

After the same manner also he took the cup, and when he had supped, saying,

This cup is the New Testament in my blood: this do ye, as often as ye drink it, in remembrance of me.

For as often as ye eat this bread and drink this cup, ye do shew the Lord's death till he come. (So if death comes; it has to Passover you.)

He leadeth me in the path of righteousness for his name's sake. Psalm 23:3b. (In the way of righteousness is life and in the pathway thereof, there is no death. Proverbs 12:28,

Yea though I walk through the valley of the shadow of death, I will fear no evil: for thy are with me: Psalm 23:3a,b. (Riches profit not in the day of wrath: but righteousness delivereth from death. Proverbs 11:4. (I am come that they might have life, and that they might have it more abundantly John 10:10 b; JESUS said "I will never leave thee or forsake thee," Hebrews13: 5b. Walk through the valley, we don't have to stop in the valley under the shadow of death.

God said, "He that dwelleth in the secret place of the Most High shall abide under the shadow of the Almighty.

So if you are dwelling in the secret place walking through the valley, which is stronger, God or the shadow of death?)

Thy rod and thy staff they comfort me. Psalm 23:4c. (And ye have forgotten the exhortation which speaketh unto you as unto little children, My son, despise not thou the chastening of the LORD, nor faint when thou art rebuked of him:

For whom the LORD loveth he chasteneth, and scourgeth every son whom he receiveth.

If ye endure chastening, God dealeth with you as sons; for what son is he whom the father chasteneth not?

But if ye be with out chastisement, whereof all are partakers, then ye are bastards, (only what is Gods' that don't mind being corrected or chastened.) and not sons.)

Thou prepareth a table before me in the presence of mine enemies: thou anointeth my head with oil; my cup runneth over. Psalm 23:5. 9

Thy throne, O, God is forever and ever: the scepter of thy kingdom is a right scepter,

Thou lovest righteousness, and hatest wickedness: therefore God hath anointed thee with oil of gladness above thy fellows.

He has given unto us, his Spirit, for us to reign here on earth.

The gifts of God; are the return of his very own character to us:

Power: The Holy Spirit give power, to reign on earth, and to perform the will of God.

Jesus said, "Behold, I give unto you power to tread on serpents and scorpions, and over all the power of the enemy: and nothing shall by any means hurt you. LUKE 10:19)

Riches: the Holy Spirit give, wealth, virtue, excellence.

(That the Gentiles should be fellow heirs, and of the same body, and partakers of his promise in Christ by the gospel. Ephesians 3: 6.

And if children, then heirs; heirs of God, and joint-heirs with Christ: if so be that we suffer with him, that we might be glorified together.Romans 8:17 .

Wisdom: the Holy Spirit give, understanding, to perform moral judgment, and moral insight. 1 Kings 3: 5-28, Proverbs 2:1-9.

Strength: the Holy Spirit give; ability, force, to be strong, courageous, never failing, life eternal, he is life. So never give up or in: "Put on the whole armour of God, that ye may be able to stand against the wiles of the devil. Philippens 6:11.

Wherefore take unto you the whole armour of God, that ye may be able to withstand in the evil day, and having done all stand." Philippians 6: 13.

Honour: the Holy Spirit gives favor, to display splendor. Luke 10: 17-20

Glory: the Holy Spirit gives power and splendor to shine in darkness. (Matthew 5:14. Ye are the light of the world. A city that is set on a hill cannot be hid.)

Blessing: the Holy Spirit gives you a pronounced fortune; to give to others. (For whosoever shall call upon the name of the LORD shall be saved. Romans 10:13)

Surely goodness and mercy shall follow me all the days of my life and I will dwell in the house of the LORD forever. Psalm 23:6.

I am commanded by God to write this book so that you may understand whose you are, and realize that Christ in you are the hope of glory.

He is the very power of our covering, It Is Christ that restores our souls right here on earth, and make our covering complete.

We are made in the image of the one true and living God Jehovah himself, not a dead god, but God himself, love power and a sound mind.(without disobedience and sin.)

We are the impression of the likeness of who God is: when we are restored.

Therefore we have to be reconciled by the blood of Jesus, to be restored and reconciled, to God, made capable of loving, and forgiving again.

The Lord said we have to love even our enemies. Now that's a tough one; when we can't even love the ones that are not our enemies.

Reconciliation; is a process whereby two or more people are brought together again through the bond of love to reestablish peace, friendship and bond a relationship, to resolve and settle a matter.

The acceptance of the atonement or the way that we are brought together enables us to forgive and receive forgiveness, without harboring resentment or retaliation.

It is Jesus that brought us together again, and provided an entrance to the Father through the torn veil, by his own blood.

Now we can come boldly to the throne of grace and find mercy. We have been reconnected and bonded by perfect love, restored.

Restoration: to restore, make like new, to be new, a new way of life, a new way of thinking. No fear, no shame, no embarrassment; you are delivered of whatever caused the disconnection between God and you, and from the source of the perception of the things that brought destruction and decay.

You are not ashamed of the saving grace and the mercy of God.

The Bible says: And they overcame him (Satan) by the blood of the Lamb (JESUS) and the word of their testimony, (they found strength to give God the glory by telling what Jesus had delivered them from) and they loved not their souls even unto the death.

As much as we don't like to admit our deliverance; our tell our real testimony: we should remember that it is someone else' deliverance.

It is to **strengthen you** and aid in **your healing** and **deliverance**, that who ever you tell it to will also loose them from bondage: that they two may be healed and delivered.

They need to know that just as Jesus died for you and your sin, he died for theirs also.

Some times we act so holy, that we can't even give a sinner a drink of living water, your testimony is that living water.

No. God doesn't remember our sin any more, but we know what Jesus delivered us from, and if we are to walk in the power of God we should love Jesus enough to help someone else, as I tell them that just like Me: he has forgiven me for adultery, fornication, lying, and what ever else that I did. Even to having an abortion.

Yes me I was a sinner. And as he has forgiven me he will forgive you too. We have all sinned, but the great thing is Jesus died for whatever the sin is; it's all sin to God.

And the only sin that won't be forgiven is blasphemy of the Holy Ghost.

If we don't want to blasphemy him maybe we shouldn't say that we are saved when we continue to do the same things that we say he has forgiven us for, on that note I'm going to say, "Put on Christ."

Chapter 6

Jesus wants us to walk in his power:

JESUS led the seventy out, and said, "But ye shall receive power after that the Holy Ghost is come upon you: and ye shall be witnesses unto me both in Jerusalem, and in all Judea, and in Samaria, and unto the uttermost part of the earth;

And when he had spoken these things, while they beheld, he was taken up: and a cloud received him out of their sight. (He went back to Heaven alive, just as Enoch, Elijah, and Moses; yes, Moses: If God wanted you to die and come to him, Jesus would have showed you some more ways to do it: but he didn't, if you are suppose to die to go to heaven where God is. Jesus never would have went back alive, he would have stayed dead.)

If you are suppose to die why do you do everything you can to stay alive, I'll say it again,: God has put eternity in you heart, the desire to live forever. And nothing can replace it if you have a desire to have Jesus as Saviour and Lord.

To see the visions of God you must realize that line must be on line, precept on precept, precept on precept, here a little and there a little, and the Holy Ghost will lead and guide you.

Jesus said to the disciples and us; "Verily, verily, I say unto thee, we speak that we do know, and testify that we have seen; and ye receive not our witness.

If I have told you earthly things, and ye believe not, how shall ye believe, if I tell you of heavenly things?"

But as it is written, Eye hath not seen, nor ear heard, neither hath entered into the heart of man, the things which God hath prepared for them that love him.

But God hath revealed them unto us by his Spirit: for the Spirit searcheth all things, yea, the deep things of God..

Now we have received, not the spirit of the world, but the Spirit which is of God; that we might know the things that are freely given to us of God.

Which things also we speak, not in words which man's wisdom teacheth, but which the Holy Ghost teacheth; comparing spiritual things with spiritual.

But the natural man receiveth not the things of the Spirit of God: for they are foolishness unto him: neither can he know them, because they are spiritually discerned.

For they that are after the flesh do mind the things of the flesh; (Say they know God but are reprobates, just can't be conformed to the word of God so they change

it so that it doesn't cut) but they that are after the Spirit the things after the Spirit.

Howbeit when he, the Spirit of truth is come, he will guide you into all truth: for he shall not speak of himself; but whatsoever he shall hear, that shall he speak; and he will shew you things to come.

And the Lord said, "Write."

So I did as I was commanded, I put my pen to the paper, and began to write as I was commanded.

I beheld till the thrones were cast down, and the Ancient of Days (Jehovah God himself) did sit. Whose garment was white as snow, and the hair of his head was like the pure wool: his throne was like a fiery flame, and his wheels as burning fire.

A fiery stream issued and came forth from before him: thousands thousands ministered unto him, and ten thousand times ten thousand stood before him: the judgment was set, and the books were opened.

I saw in the night visions, and behold, one like the Son of man came with the clouds. (Acts 1:9 accounts for this part of Daniel's vision.)

And when he (Jesus) had spoken these things, while they (his disciples) beheld, he (Jesus) was taken up, and a cloud received him out of their sights.

And Daniel saw him come on the clouds to heaven, he records it this way.

And came to the Ancient Of Days (Jehovah God Almighty) and they (the angles) brought him (Jesus) near before (Jehovah God Almighty) him.

And there was given him dominion, and glory, and a kingdom, that all people, nations, and languages, should serve him: his dominion is an everlasting dominion, which shall not pass away, and his kingdom that which shall not be destroyed. Daniel 7:13.

Daniel 7:27 reads;

And the kingdom and dominion, and the greatness of the kingdom under the whole heaven, shall be given to the people of saints of the Most High, whose kingdom is an everlasting kingdom, and all dominion shall serve and obey him (our complete restoration).

John saw the revelation of the vision of the restoration of the saints of God, the closer view as also Daniel saw.

He saw the vision of the Book with the seven seals released. Revelations5:1-14.

And I saw in the right hand, of him (Jehovah God Almighty) that sat on the throne, a book written and on the back side, sealed with seven seals.

And I saw a strong angel proclaiming with a loud voice.

Who is worthy to open the book, and to loose the seals thereof? (These seals were marks that represented the authenticity of this document and recorded each

position of the restoration of power, recorded in this Book.

The reason that this book was sealed with the seven seals was because: God removed the power that Adam should have had, when he disobeyed God. God sealed it up, declaring that it would not be released again until The coming of Jesus the Saviour, that would redeem mankind from his sin.

These seals represented the authencity of this document that could not be opened by anyone that had not the power to open it.

The person that opened this Book with the seven seals was instructed and possessed the utmost honesty, and worthiness of the contents, and was able to carry out all the commands of a King that was set before him. That could only be Jesus.

He was able to receive instructions, and therefore is set to obtain power of the King to act as King, and execute the duties of the KING OF KINGS AND LORD OF LORDS.

In this case Jehovah God Almighty, also known as the Ancient of Days, gives power to Jesus, as the Lamb which had been slain.

And the Bible says that no man in heaven, nor in the earth, neither under the earth, was able to open the book, neither to look thereon.

And I wept much, because no man was found worthy to open and read the book, neither to look thereon.

(This Book had so much power generating from it, it was surrounded by the power and glory of Almighty God, and only, Jesus in his holiness as the Son of God was able to ascend into that realm of holiness, and anointing, of glory and righteousness, to receive The Book .

He was found guilty of being innocent of sin, and paid the price of death for death being raised from the dead, to life, he presented the plan, to us of his power, to reinstate us with power, for us to take back what was stolen from us: to release us from the death trap to give us newness of life, that all man might go free.

God's glory is as a rainbow about the throne, his throne is like a fiery flame and his (eyes wheels are like burning fire.)
A fiery flame issued and came from before him.

The splendor of his awesomeness; radiates power; like a jasper and a sardine stone; when it is exposed to the light; only this was like an electrical field that gave brilliance, as of the sun, because the glory of God and the LAMB is the light thereof.
Magnificent colors of power, so awesome a sight; that had a force that no ordinary man or being could ascend into it.

The Little Book itself was filled with power, that no one could look upon its' words because the words was power.

And one of the elders saith unto me.

Weep not: behold (Look! He said to me, with great excitement, the Lion Jesus) of the tribe of Judah, the root of David hath prevailed (has triumph over all things that pertained to life.) to open the Book, and to loose the seven seals thereof.

And I beheld (I looked) and lo, in the midst of the elders, stood a LAMB.

(Jesus) as it had been slain, (crucified) having seven horns and, seven eyes, which are the seven Spirits of God, sent forth into all the earth.

And he came and took the book out of the right hand of him (Jehovah) that sat on the throne.

And when he (Jesus) had taken the book, the four and twenty elders fell down before the Lamb (Jesus) every one of them having harps, and golden vials full odours, which are the prayers of the saints,

And they sung a new song saying, **Thou art worthy to take the book, and to open the seals thereof: for thou wast slain, and hast redeemed us to God by thy blood out of every kindred, and tongue, and people, and nation;**

And hast made us unto pour God kings and priests: and we shall reign on earth.

And I beheld, and heard the voice of many angels round about the throne and the beast and elders: and the

number of them was ten thousand times ten thousand, and thousands of thousands, (The same number that Daniel saw and heard.)

Saying, with a loud voice, "Worthy is the LAMB that was slain to receive **power,** and **riches**. And **wisdom**, and **strength,** and Honour and **glory** and **blessing**."

And every creature which is in the heavens, and on earth and under the earth, and such as are in the sea and all that are in them, heard I saying,

"**Blessing, and Honour and glory, and power, be unto him that sitteth upon the throne, and the LAMB forever and ever.**"

And the four beasts said, "Amen."

And the four and twenty elders fell down, and worshipped him that liveth forever and ever.

(Then; Jesus returned to earth after receiving power, to empower the disciples and those that would be followers after them, and that power is for us to partake of today.)

The Bible says:

And Jesus came and spake unto them, saying, "All power is given unto me in heaven and in earth. Go ye therefore, and teach all nations, baptizing them in the name of the Father and of the Son, and of the Holy Ghost:

Teaching them to observe all things whatsoever I have commanded you: and lo, I am with you always, even unto the end of the world. Amen.

And he said unto them, "Go ye into all the world and preach the gospel to every creature.

He that believeth and is baptized shall be saved: but he that believeth not shall be damned.

And these signs shall follow them that believe,

In my Name shall they cast out devils; they shall speak with new tongues: They shall take up serpents; and if they drink any deadly thing it shall not hurt them, they shall lay hands on the sick and they shall recover."

Jesus said, "Verily, verily I say unto you, He that believeth on me, the works that I do shall he do also; and greater works than these shall he do; because I go unto my Father."

When Jesus, ascended up on high; All; power was given unto him, and he has given us of that power also.

Jesus in turn, after receiving all power came back and empowered us to carry out the work.

He commanded us to do greater works just as we have seen him do, and with power.

Our vessels has been restored and the light of God now illuminates in our lives.

We are the light of the world, the salt of the earth, (light makes known what is in the darkness, and salt preserves)

Our lights are suppose to expose sin and make clear the path to Jesus, to light the way to righteousness and life.

That same Spirit that raised up Jesus from the dead is suppose to dwell in us!

If that same Spirit that raised up Christ from the dead dwell in us, we are recharged reconnected to God our Father, right now!!!

Chapter 7

Jesus gave us of his power; now the power that abideth in us is of the Seven Spirits of God.

For God who commanded the light to shine out of darkness, and hath shined in our hearts, to give the light of the knowledge of the glory of God in the face of Jesus Christ.

But we have this treasure in earthern vessels that the Excellency of the power may be of God, and not us.

For God, who commanded the light to shine out of darkness, and has shined in out hearts, to give the light of the knowledge of the glory of God in the face of Jesus Christ.

Perfect love casts out all fear, Jesus presented us with the gift of love, power and renewed our minds.

To be the results of the power of God, by the Holy Spirit in time, to bring the kingdom of God into view.

You are safe, and the effects of the cross, the blood of Jesus Christ, his resurrection allows you to be an inheritor; therefore you have **immunity**-an inherited required or induced resistance to any pathogen, or agent that causes disease especially microorganisms such as bacterium or fungus that can cause death.

You are safe bye the cross.

You must become immoveable, incapable of being altered, you must be just like the mustard seed, know what God has said about you and your situation. And believe that it is impossible for God to lie, or his love to fail.

Jesus preached the kingdom of God, while moving from place to place to show us the effects of God kingdom on Earth.

Jesus began to bring about the results of relief; he began to show us Gods vision for the purpose of the death, burial, and resurrection of himself. So that the direction of our live will be forever changed.

Once we received this knowledge the effects of our live change will bring about the results of relief.

Forcing the enemy's troops to withdraw and surrender.

By our preaching of the kingdom of God; the gospel of Good News we are to raise Jesus up, and he becomes a point, where motion supersedes our inability. Gods love will always release us from the out come of the penalty.

By grace we are saved, it is Gods unmerited favor.

God's gift of love toward us.

When we raise Jesus up we end the seize of the enemy causing the enemy's demons to withdraw.

We bring the cross into view as we plead the body and the blood of Jesus which brings about our desired results. To cause the Holy Spirit to act on our behalf.

He has released us from the penalty of death, hell and the grave. Now we have safe haven of the promise.

When we stand on Gods promises we show the devils demons the receipt of payment: PAID IN FULL.

Jesus is unlimited-he is the point were motion or action proceed our inability.

He is above every imagination at the name of Jesus every knee shall bow and ever tongue shal confess that; JESUS IS LORD, to the glory of GOD THE FATHER, and he shared the inheritance with us that we may be reestablished.

Chapter 8

Jesus shared his power with us: now the power that abideth in us, are: the Seven Spirits of God.

1. **Power**- The Holy Ghost manifesting his power in us for a positive change. He says, "Behold I give unto you power to tread on serpents and scorpions, and over all the power of the enemy, and nothing by any means shal hurt you."

2. **Riches**- He that spared not his own Son, But delivered him us to us all, How shal he not with him also freely give us all things? The silver is mine, the gold is mine saith the Lord of hosts.

 But my God shall supply all mine needs according to his riches in Christ Jesus.

3. **Wisdom**- The fear of the Lord is the beginning of wisdom; and the knowledge of the Holy One is understanding. (We are to take what is known and reveled of God: by the Holy Ghost, and use it as our instructor, we obey!)

 The Bible says, give instruction to a wise man and he will be yet wiser, teach a just man and he will increase in learning.

 The fear in the Lord is the begging of wisdom and the knowledge of the Holy is understanding.

 For by me thy days shall be multiplied, and the years of thy life shal be increased. Ecc.9:9-11.

 Now therefore hearken unto me, O yea children blessed are they that keep my ways, here instructions and be wise, and refuse it not.

 Blessed is the man that heareth me watching daily at my gate. Waiting at the post of my doors. For whoso findeth me findeth life, and shal obtain favor of the Lord. Ecc.8:32-33.

4. **Strength**- Neh.8:18. Then said he unto him go your way, eat the fat, and drink the sweet, and send portions unto them whom nothing is prepared for this day is holy unto the LORD;

 Neither be ye sorry: for the joy of the Lord is my strength. They shal show me the path of life: and thy presents is fullness of joy: at tho

47

right and thy side is there pleasure for ever more. PSALM 15:11.

5. **Honour**- Glory and Honour are in his presents and strength and gladness are in his place. Give unto the Lord, you kindred of people, give unto the Lord glory and strength.

 Give unto the Lord the glory to his name: bring an offering and come before him, worship the Lord in the beauty of holiness. (God alone is worthy of our highest praises worship and honor
 Jesus makes it clear you can not honor the Father unless you first honor and acknowledge the Father and the Son. And we should greatly esteem and respect the Holy Spirit by him our love flow threw.)
 The Bible says, Let the elders who rule well be counted of double honor. (and not worship)

6. **Glory-** EXODUS 33:12. and Moses said, unto the LORD (JEHOVAH) See, Thou sayest unto me, bring up these people, and thou has not let me know whom thou will send with me. Yet, thou has said, "I know the bye name. And thou has found grace in thy site."
 Now therefore I pray thee, "If I have found grace in thy site shew me now thy way, that I mat know thy and thy find grace in thy site,

and consider that this nation is thy people,"
and he said,: "My presents shall go with the,
and I will give ye rest."
(The meek will he guide and the meek will he
teach his way. PSALM 25:9)
And he (Moses) said unto him, If thy present
go not with me, carry us not of hence.
For where in shall it be know here that I and
thy people have found grace in thy site? I it
not in that thou goest with us? So shall we be
separated, I am thy people from all the people
that are upon the face of the earth."

And the Lord said unto Moses, "I will do this
thing also that thou has spoken that thou has
found grace in thy site, and I know the bye
name." And he (Moses) said, "I beseech thee
shew me thy glory."
And he said, "I will make all my goodness
pass before thee; and I will proclaim the name
of the Lord (Jesus) before the, and I will be
gracious to whom I will be gracious, and I will
show mercy on whom I will show mercy.
And he said canst not see my face; for there
shall no man see me and live.
And the LORD God said, Behold there is a
place by me, and thou shal stand upon a rock:
and It shall come to past, while my glory
passeth by, that I will put the in the cleft of
the rock and will cover the with thy hand as
I pass by: And I will take away my hand, and
thy shall see my back parts: But my face shall

not be seen.

And the Lord (God) descended on the cloud, and stood with him there, and proclaimed (introduced) the name of the LORD (Jesus). And the Lord (God) passed bye before him and proclaimed, "The LORD (Jesus) the Lord God, merciful, Longsuffering, an abundant, in goodness and truth keeping mercy for thousands, for giving iniquities and transgressions in sin, and will no means clear the guilty: Visiting the iniquity of the Father upon the Children's, children, until the third and forth generation." EXOUDS 34: 9-10

And he said, "Now I have found grace In thy sight O Lord, let my Lord (Jesus) I pray thee, go among us: for it is a stiff necked people; and pardon our iniquity and our sin, and take us for thine inheritance,"

And he said, "Behold, I make a covenant: before all thy people I do marvels, such as have not been done in all the earth nor in any nation: and all the people among which thou art will see the work of the LORD: for it is a terrible thing what I will do with thee."

Chapter 9

"Ye shall make you no idols nor graven images, neither rear ye up a standing image, neither will ye set up any stone image in your land, to bow down to it, for I am the LORD your God.

Ye shall keep my Sabbaths: (Passover, Pentecost, Yum Kippur, and Ingathering: the Feast of Trumpets.)

And reverence my sanctuary; I am the LORD thy God.

If you walk in my statues and keep my commandments and do them;

Then I will give you rain in due season and the land shall yield her increase and the trees of the field shall yield her fruit.

Thou shal truly tithe all the increase of the seed, That the field bringing forth year by year.

And your threshing shall reach into the vintage (old that is stored), and the vintage shall reach into the sowing time, and ye shall eat your bread to the full and dwell in your land safely.

And I will give peace in the land, and ye shall lie down and none shall make you afraid and I will rid all evil beast out of the land neither shall the sword go through your land. (No death, no Famine, no destruction, no loss of anything.)

And ye shall chase your enemies and they shall fall before you by the (Word) sword.

BEHOLD, I will send an angel before thee, to keep thee in the way and bring ye in the place that I have prepared.

Beware of him, and obey his voice, provoke him not; for he will not pardon your transgressions; for my name is in him. But if thou shall indeed obey his voice, and do all that I speak, then I will be an enemies to thy enemies and an adversary to thy adversary.

For mine angel shall go before thee in unto the Amorites, and the Hettites, and the Perizzites, and the Cannanites, and Hevites, and the Jebusites: I will cut them off.

Thou shalt not bow down to their gods, nor serve them, nor do after their works; but thou shalt utterly break down their images.

And ye shall serve the LORD your God, and he shall bless thy bread, and thy water: and I will take sickness from the midst of thee.

There shall nothing cast their young, nor be barren in thy land, the number of thy days I will fulfill.

I will send fear before thee, and I will destroy all the people to whom thou shalt come, and I will make all thy enemies turn their backs unto thee.

And I will send hornets before thee, which shall drive out the Hevites, the Cannanites, and the Hevites from before thee.

I will not drive them out from before thee in one year, lest the land become desolate and the beast of the field multiply against thee.

By little and little I will drive them out from before thee,

Until thou be increased, and inherit the land.

And ye shall chase your enemies and they shall fall before you by the sword.

And five of you shall chase a hundred and a thousand of you shall put ten thousand to flight. And your enemies shall fall before the sword.

For I have respect unto you, and will make you fruitful, and multiply you, and establish my covenant with you.

And ye shall eat of the old store, and bring forth old because of the new. (Before the old is gone I will supply new.)

And I will set my tabernacle (my dwelling place) among you, and my soul shall not abhor you.

And I will walk among you, and will be your God, and ye shall be my people.

I am the LORD your God, which brought you out of the Land of Egypt that you should not be their bondmen: and I have broken the band of your yoke, and made you go upright."

And it came to pass when Moses came down, from the Mount Sanai with the two tables of Testimony in Moses hand.

The Bible says that Moses, wist not that his face shined, (It radiated with the brilliance from being in the presence of love and of the glory of God.)

And the children of Israel was afraid of him. They were afraid to come near him.

And Moses called unto Aaron, and all the rulers of the congregation returned unto him; and Moses talked with them.

And afterward all the children of Israel came nigh: and he gave them Commandment all that the LORD had spoken with him in the Mount Sanai.

And until Moses had done speaking with them, he put a vail on his face. (so that the children could not see the coming of Jesus).

But when Moses went in before the LORD to speak with him, he took the vail off, until he came out.

And he came out and spake unto the children of Israel that which he was commanded.

And the children of Israel saw the face of Moses that the skin of Moses' face shone: and Moses put the vail upon his face again, until he went in to speak with him.

Jesus said, "Moses rejoiced to see my day and saw it." This is what he was speaking of, God revealed the entire promise to him: to Moses on the Mount.

Chapter 10

But if the ministration of death written and engraved in stone was glorious, so that the children of Israel could not steadfastly behold the face of Moses for the glory of his countenance: which glory was to be done away.

How shall the ministration of the Spirit be rather glorious?
For if the ministration of condemnation be glorious, much more doeth the ministration of righteousness exceed in glory.

For even that which made glorious had no glory in this respect, by reason of that exalteth. (Restoration to life: with power.)

For if that which was done away with was glorious (the ministration of death) Much more that which remaineth is glorious (redemption to life), and rest for the people.

Seeing then that we have such hope, we use plainness of speech:

And not as Moses, which put a veil over his face, that the children of Israel could steadfastly look to the end of that which is (done away with death) abolished.

For God hath not given us the spirit of fear: but of power, and of love, and of a sound mind.

But (life) is now made manifest by the appearing of our Saviour Jesus Christ, who hath abolished death, and brought life and immortality, to light through the gospel.

(This word abolished means: in the Hebrew: to blot out, to utterly destroy. The American Heritage Dictionary reads: to abolish is to counteract the forces (powers) or the effectiveness of).

The prophesy of Isaiah 25:8 reads,

He will swallow up death in victory: and the LORD will wipe away the tears off all faces, and the rebuke of his people shall he take away from off the earth: for the LORD hath spoken it.

And your covenant with death shall be disannulled, (made void) and your agreement with hell shall not stand: when the overflowing scourge shall pass through, then ye shall be trodden down by it.

From the time it goeth forth it shall take: for morning by morning shall it pass over, by day and by night; and it shall be a vexation: only to understand the report.

The Bible says; But even unto this day, when Moses is read, the Vail is upon their heart.

Nevertheless when it shall turn to the Lord, the Vail shall be taken away.

For God who commanded the light to shine out of darkness, hath shined in our hearts, to give the light of the knowledge of the glory of God in the face of Jesus Christ.

But we have this treasure in earthern vessals, that the excellency of the power might be of God and not us.

Jesus explains that Gods' glory is ever present.

John 11:1-4; explains it this way,

Now a certain man was sick, named Lazarus, of Bethany, the town of Mary and her sister Martha. (It was that Mary which anointed the Lord with ointment, and wiped his feet with her hair, whose brother Lazarus was sick)

Therefore his sisters sent unto him, saying, "Lord, behold, **he whom thou lovest is sick**."

When Jesus heard that he said, "This sickness is not unto death, but for the glory of God, that the Son of God might be glorified thereby."

Jesus said unto her, "Thy brother shall rise again."

Martha said unto him "I know that he shall rise again in the resurrection at the last day."

Jesus said unto her, "I am the resurrection, and the life, he that believeth in me, though he were dead yet shall he live.

And whosoever liveth (that is alive in the present) and believeth in me shall never die. (Shall continue on). Believeth thou this?"

(Jesus is telling Martha and us, I bring the promise of My Father, to its fulness. That you might have the ability to live, to continue on, to break free of sin, now! This cures of death was broken before their very eyes.

Death hath no more power over you, any more, whoever hath heard read and believed the gospel, this promise is for you.)

Jesus said, "Take away the stone," Martha the, the sister of him that was dead, saith unto him, "LORD, by this time he stinketh for he hath been dead four days."

Jesus saith unto her, "saith I not unto thee, that, if thou wouldest believe, thou shouldest see the glory of God?"

Then they took away the stone, from the place where the dead were laid.

And Jesus lifted up his eyes, and said, "Father, I thank thee that thou heard me. And I know that thou hearest me always: but because of the people which stand by I said it, that they might believe that thou hast sent me."

And when he had spoken, he cried with a loud voice, "Lazarus, come forth."

And he that was dead came forth, bound hand and foot with grave clothes: and his face was bound about with a napkin.

Jesus said unto them, "Loose him, and let him go."

Then many of the Jews which came to Mary, and had seen the things which Jesus did believed on him.

In the gospel of Matthew 10:6,

Jesus commanded us to preach the gospel; the Good News of the Kingdom, to the lost sheep. (That news is: things shall not continue as they are, with us, but we have been redeemed; All of us that were lost in our sin.)

The Bible says, but go rather to the lost sheep of the house of Israel.

And as you go, preach, saying "The kingdom of heaven is at hand.

Heal the sick, cleanse the lepers, raise the dead, cast out devils: freely ye have received freely give.

Provide neither gold, nor silver nor brass in your purses.

Nor script for your journey, neither two coats, neither shoes, nor yet staves, for the workman is worthy of his meat.

In the book of Mark; Jesus commands power upon us to perform the works of God.

The Bible says that; and afterward he appeared unto the eleven as they sat at meat, and upbraided them with their unbelief and hardness of heart, because they

believed not them which had seen him after he was risen.

And he said unto them, "Go ye into all the world and preach the gospel to every creature.

He that believeth and is baptized shall be saved: but he that believeth not shall be damned.

And these signs shall follow them that believe: In my name shall they cast out devils; they shall speak with new tongues:

They shall take up serpents; and if they drink any deadly thing it shall not hurt them; they shall lay hands on the sick and they shall recover.

The commission did not stop with the disciples or the Apostles before us, Jesus prayed for us also.

He said, "I pray for them: I pray not for the world, but for them which thou hast given me; for they are thine.

And all mine are thine, and thine are mine; and I am glorified in them.

And now I am no more in the world, but these are in the world, and I come to thee, Holy Father, keep them through thine own name those thou hast given me, that they may be one, as we are one.

While I was in the world, I keep them in thy name; those that thou gavest me I have kept, and none of them are lost, but the son of predition; that the scripture might be fulfilled.

And now I come to thee: and these things I speak in the world, that they might have my joy. Fulfilled in themselves.

I have given them the word; and the world hath hated them, because they are not of the world.

I pray not that thou shouldest take them out of the world, but that thou shouldest keep them from the evil.

They are not of the world, even as I am not of the world.

Sanctify them through thy truth; thy word is truth.

As though hast sent me into the world, even so have I also sent them into the world.

And for their sakes I sanctify myself, that they also might be sanctified through the truth.

Neither pray I for these alone, but for them also which shall believe on me through their word.; That they all may be one; as thou, Father, art in me, and I in thee, that they also may be one in us; that the world may believe that thou hast sent me.

And the glory which thou hast given me I have given them: that they may be one, even as we are one,

I in them, and thou in me, that they may be made perfect in one; and that the world may believe that thou hast sent me, and has loved them, as thou hast loved me.

Father, I will that they also, whom thou hast given me, be where I am; that they may behold my glory: which thou hast given me; for thou lovest me before the foundation of the world.

O righteous Father, the world hast not known thee, and these have known that thou hast sent me.

And I have declared unto them thy name, and I will declare it: that the love wherewith thou hast loved me may be in them and I in them."

(The total injection, divine impartation of love that seemed to be lost to us, now being restored, a total recharge of love, straight from agape love.)

Chapter 11

7. **Blessing**-The act of declaring favor; or goodness upon others, allowing them to partake and possess something, or be in a condition, having obtained something that they couldn't ordinary obtain or receive for themselves.

A blessing is more than mere empty and powerless words: but rather is powerful. We have been given the power to bless; only. (Power- the ability to change situations and circumstances, to perform an activity, administer benevolence or deeds, through love.

However, this power is used with authority of the word of God in our mouth.

It suggests a moral right and privilege, which comes directly from God from which we have both power and authority.

Blessing-the Bible says, 'If ye shall ask anything in my name I will do it."

Jesus said, "Verily, verily, I say unto you, any thing that they shall ask, it shall be done for them of my Father Whatsoever ye shall bind on earth shall be bound in heaven; and whatsoever ye shall loose on earth shall be loosed in heaven.

Again I say unto you, that if two of you shall agree on earth as touching any thing that they ask, it shall be done for them of my Father, which art in heaven.

(When two of us stand or sit facing each other as we touch and agree, we can see the habitation of the tabernacle and the Mercy seat of God in the midst of us.

Just like the Ark of the Covenant that the children of Israel carried upon their shoulders with the two angles facing each other.

When we face each other we create the habitation of a tabernacle and the mercy seat where the Lord will meet us. And be in the midst of us, just as it was in the wilderness when Moses built the ark. Two angles faced each other facing the mercy seat,

Just as it were with Mary Magdalene looked in the sepulcher where Jesus was laid without at the sepulcher, weeping, and she wept, she stooping down, and looked into the sepulcher,

And seeth two angles in white sitting, one at the head, and one at the feet, where Jesus had laid.

Mary saw a figure of the true Ark of the mercy seat, verified by the testimony of the Ark of the Testimony that the children carried with them, which was a figure of the true that was to come, now she stands in it's presence.

When we come together, on one accord, facing each other, we prepare a place of habitation for the power of the Holy Ghost to be in the midst of us, we create a tabernacle a place for God to commune with us.)

The powers behind our blessing are influenced by the Holy Ghost, who is able to bring (them) whatsoever we ask, or think, in Jesus' name: to pass.

The power of our blessings are so powerful, that even if you speak a blessing upon someone, and you wanted to change your mind and take it back, you can't.
It shall be performed.

God has commanded his blessings upon us, that we might be a blessing to others.)

For thus saith the LORD that created the heavens; God himself that formed the earth and made it: he hath established it: he created it not in vain, he formed it to be inhabited:
"I am the LORD: and there is none else.

I have not spoken in secret in a dark place of the earth: I said not unto the seed of Jacob, Seek ye me in vain: I the LORD speak righteousness; I declare things that are right.

For this commandment which I command thee this day, it is not hidden from thee, neither is it far off.

It is not in heaven, that thou shouldest say, " who shall go up for us to heaven, and bring it down to us, that we may hear it and do it?"

Neither is it beyond the sea, that thou shouldest say. "Who shall go over the sea for us, and bring it unto us, that we may hear it and do it?"

But the word is very neigh unto thee, in thy mouth, and in thy heart, that thou mayest do it". Deuteronomy 30:11-14.

And it shall come to pass. If thou shalt hearken diligently unto the voice of the LORD thy God, to observe and do all his commandments which I command thee this day, "that I will set the on high above all the nations of the earth.

And all these blessings shall come on thee, if thou shall hearken unto the Lord thy God.

Blessed shall thou be in the city, and blessed shall thou be in the field.

Blessed shall be the fruit of thy body, and the fruit of thy ground, and the fruit of thy cattle, and the increase of thy kine (cows), and the flock of thy sheep,

Blessed shall thou be when thou comest in, and blessed shall thou be when thou goest out.

The Lord shall cause thine enemies that rise up against thee to be smitten before thy face: they shall come out against thee one way, and flee before thee seven ways.

The Lord shall command the blessings upon thee in the storehouses, and in all that thou settest thine hand unto: and he shall bless thee in the land which the LORD thy God giveth thee.

The LORD shall establish thee a holy people unto himself, as he has sworn unto thee: if thou shalt keep the commandments of the LORD thy God, and walk in his ways.

And all the people of the earth shall see that thou are called by the name of the LORD; and they shall be afraid of thee.

And the Lord shall make thee plenteous in goods, in the fruit of your body, and the fruit of thy cattle, and in the fruit of thy ground, in the land which the LORD sware unto thy fathers to give thee.

The LORD shall open unto thee his good treasure, the heavens to give rain unto thy land in his season, and bless all the work of thine hands: and thou shall lend unto many nations, and thou shall not borrow.

And the LORD shall make thee the head, and not the tail: and thou shall be above only: and thou shall not be beneath: if thou shall hearken unto the commandments

of the LORD thy God, which I command thee this day, to observe and do them:

And thou shalt not go aside from any of the words which I command thee this day, to the right hand, or to the left, to go after other gods to serve them.

And it shall come to pass, when all these things come to pass, when all these things come upon thee, the blessings and the curse, which I have set before thee, and thou shall call them to mind, among all the nations, whither the Lord thy God hath driven thee.

And shall return unto the LORD thy God, and shall obey his voice according to all that I command thee this day, thy and all thy children with all thy heart, and with all thy soul;

That when the LORD thy God will turn thy captivity, and will return and gather thee from all the nations, whither the Lord thy God hath scattered thee:

And the LORD thy God will bring thee into the land which thy fathers possessed, and thou shall possess it:

And he will do thee good and multiply thee above thy fathers.

And the LORD thy God will circumcise thine heart, and the heart of thy seed, to love the LORD with all thine heart, and with all thine soul, that thou mayest live.

And the LORD thy God will put all these curses upon thine enemies, and on them that hate thee, which persecuted thee.

And thou shalt return and obey the voice of the LORD, and do all his commandments which I command thee this day.

See, I have set before thee this day life and good, and death and evil:

In that I command thee this day to love the Lord thy God, and walk in his ways and keep his commandments and his statues, and his judgments that thou mayest live and multiply: and the LORD thy God shall bless thee in the land whither thou goest to possess it.

But if thy heart turn away, so that thou wilt not hear, but shall be drawn away, and worship other gods and serve them:

I denounce unto you this day, that ye shall not prolong your days upon the land, whither thou passeth over Jordan to go to possess it.

I call heaven and earth to record this day against you, that I have set before you life and death, blessing and cursing, therefore choose life, that both thou and thy seed may live:

That thou mayest love the Lord thy God, and that thou mayest obey his voice, and that thou mayest cleve unto him: for he is thy life, and the length of thy days."

God is not a man that he should lie; neither the son of man, that he should repent: hath he said, and shall not do it? Or hath he spoken, and shall not make it good?

Behold I have received commandment to bless, and he hath blessed; and I cannot revise it. Nunbers23:20

This passage is saying that God himself hath given power to my/our words, to bless, and to cause miracles to happen. When I/you bless, and that blessing is released, the motion of the law of blessing are released, and set into motion, (act of faith) And even God himself cannot revise it, because he himself set the law of faith and the law of motion into action, to bless and his word not to return to him (void) unfulfilled

It is God our Father Jehovah that has adopted us, through our Lord and Saviour Jesus Christ, and he has given us the power to perform the work of the kingdom through his word, which can never fail.

We have this power that we might be a blessing to others.

We must lay hold on love, mercy and tender loving kindness.

Chapter 12

With words; God created the heavens and the earth, he said, "Let there be.") and whatsoever he called into existence, it was so.

Jesus said unto them, "Why are ye so fearful, O ye of little faith?" he rebuked the winds and the sea; and there was a great calm.

But the men marveled, saying, "What manner of man is this, that the wind and the sea obey him."

The Bible says,

When even (evening) was come, they brought unto him many that was possessed with devils, **and he cast out the spirits with his words, and healed all that were sick.**

Jesus taught the disciples (which would later be called Apostles) how to have compassion with their words; to heal the sick.

He showed them the love of God in action.

Everything that Jesus reacted to shows us that he was moved with compassion.

To have compassion is to love and to be able to loose that love through piety; to desire to spare one from suffering and pain. To release them from what ever bondage they may suffer; and we do it through by love.

Jesus spared the dead, he could not deny them the very freedom that he was to die for; every one that he came in contact with; he raised from the dead. Jesus came to restore life to us again.

Life is restored to us through the forgiveness of sin, our sin that Jesus took to the cross with him.

That we will be able to love and receive love, that we might be able to forgive and receive forgiveness, when we look to Jesus alone for help, then; we will be able to lift him above all idols: idols of gold, of silver, of stones, of wood carved with man's hands that can neither save nor deliver that can't speak or breath., lifting Jesus above all idols, and cast down every imagination that exalteth itself against the knowledge of God.

Jesus wept. (This was a cry of great **compassion** that we might see why he came into the world.

He said, "He that believeth on me, believeth not on me, but on him that sent me: (Jehovah God is who he's talking about.)

(No one has to believe on me, or you for that matter, it's the love of God in us that gives power to our words; to perform the miracles of healings and deliverance, to set the captives free.)

When they look at us, they should see the love of Jesus.

Jesus said, "And he that seeth me seeth him that sent me.

Verily, verily I say unto you, He that receiveth whomsoever I send receiveth me; and he that receiveth me receiveth him that sent me.

I am come a light into the world, that whosoever believeth on me should not abide in darkness.

And if any man hear my words, and believe not, I judge him not: for I am come not to judge the world, but to save the world.

He that rejecteth me, and receive not my words, hath one that judgeth him; the word that I have spoken the same shall judge him in the last day.

For I have not spoken of myself: but the Father which hath sent me, he gave me commandment, that which I should say, and what I should speak.

And I know that his commandment is life everlasting; (Everlasting life: life without interruption or end) Whatsoever I speak therefore, even as the Father said unto me, so I speak.

He that heareth you, heareth me; and that despiseth you despiseth me; and he that despiseth me despiseth him that sent me.

Verily, verily, I say unto you, If a man keep my sayings, he shall never see death."

And the Bible says that the seventy returned again with joy, saying, "LORD, even the devils are subject unto us through thy name."

And he said unto them, "I beheld satan as lightning, fall from heaven.

Behold, I give unto you power to tread on serpents and scorpions, and over all the power of the enemy: and **nothing** shall by any means hurt you."

(Nothing- no existing thing, small or large, few or many, strong or weak, shall have any power over you.)

Notwithstanding in this rejoice not, that the spirits are subject to you,(Subject-to submit, obey your rule, direction, command: when they are commanded to do so) but rather rejoice because your names are written in heaven.

The bible says that

Death and life are in the power of the tongue: and they that love it shall eat the fruit thereof. (So if you like speaking death on yourselves you will eat the fruit of it, however if you speak life to yourselves you shall live, and have life.

The mouth of a righteous man is a well of life. Proverbs11:10a.

(**If a man does not know Gods' plan for our Salvation, he cannot lead you in to life.**)

The Bible says that ….But righteousness delivereth from death. Proverbs 11:19

In the way of righteousness is life, and in the pathway thereof there is no death. Proverbs12:28.

Chapter 13

Ye shall not fear other gods, nor bow down yourselves to them, serve them, nor sacrifice to them:

But the LORD, who brought you up out of the land of Egypt with great power and a stretched out arm, him shall ye fear, and him shall ye worship, and to him shall ye do sacrifice.

And the statues and ordinances and the law., and the commandments, which he wrote for us, ye shall observe to do for evermore and ye shall not fear other gods.

And the covenant that I have made with you ye shall not forget; neither shall you fear other gods.

But the LORD your God ye shall fear, and ye shall deliver you out of the hand of all your enemies.

Now it came to past in the third year, of Ho-She-A, son of Elah king of Israel, that Hezekiah, the son of Ahaz king of Judah, began to reign.

Twenty-five years old was he when he began to reign; and he reigned twenty and nine years in Jersusalem, his mothers name was Abi, the daughter of Zacheriah,

And he did that which was right in the sight of the LORD, according to all that David his father did.

He removed the high places, and break the images, and cut down the groves, and break in pieces the brazen serpent that Moses had made; for unto those days the children of Israel did burn incense to it: and he called it Nehushtan, (He trusted in the LORD GOD of Israel-the serpent that Moses made by the command of God was restored to life after repentance, it was never intended to be used for worship, it was a figure and shadow of Jesus on the cross) so that after him was none like him among the kings of Judah, nor any that were before him.

For he clave to the LORD and departed not from following him but kept the commandments, which the LORD commanded Moses.

And the LORD was with him and he prospered whethersoever he went forth: and he rebelled againt the king of Assyria, and served him not.

He smote the Philistines even unto Gaza, and the border thereof: from the tower of the watchmen to the fenced City.

The Bible says that: in those days was Hezikiah sick to death: and the prophet Isaiah the son of Amos came to him, and said to him,

Thus saith the LORD, "Set thine house in order: for thou shalt die and not live."

Then he turned his face to the wall, and prayed unto the LORD saying, "I beseech thee, O LORD, remember now how I walk before thee in truth and with a perfect heart, and have done that which is right in thy sight." And Hezikiah wept sore.

Hezekiah, put God into remembrance of the good, he had done for the kindom's sake. Not that God couldn't remember, but Hezikiah reminded God of how he called his chosen people Israel, into true worship, where they would worship HIM, the one true and living God, (and not dumb idols.) and the keeping of the Passover, which they had long ago ceased to do. (As most cease to do as to this very day in 2009).

For the Bible says that; Hezikiah prayed and the LORD was entreated with Hezikiah's prayer, For the Bible says that: and it came to pass, afore Isaiah was gone out into the middle court, that the word of the LORD came unto him saying,

"Turn again and tell Hezikiah the captain of my people. Thus saith the LORD, the God of David thou Father, 'I have heard thy prayer, I have seen thy tears; Behold, I will heal thee:"

(When I began to write this about Hezikiah, it really did bless me and it lifted my heart and spirit to know that Hezikiah an upright man of God was not in a hurry to die.

But he instead made supplications with prayer and tears, turning to the wall to petition God to spare his life. (As Hezekiah was so am I, and so should you be, that in us we have a petition to ask of God to spare our lives: because we have not let God's people forget him or his statues or judgments.)

God said, "I have seen thy tears: behold I will heal thee on the third day thou shall go up unto the house of the LORD.

And I will add unto thy days, fifteen years: and I will deliver thee and this city out of the hands of the king of Assyria: and I will defend this city: for mine own sake, and for my servant David's sake.

And Isaiah said, "Take a lump of figs". And they took and laid it on the boil, and he recovered.

And Hezikiah said unto Isaiah, "What shall be the sign that the LORD will heal me, and that I shall go up into the house of the LORD, that he has spoken, shall the shadow go forward ten degrees, or go backwards ten degrees?"

And Hezikiah answered, "It is a light thing for the shadow to go down ten degrees: Nay, let the shadow turn backward ten degrees."

And Isaiah cried unto the LORD: and he brought the shadow ten degrees backward, by which it had gone down in the dial of Ahaz.

(Hezikiah did what was right in the sight of God and God blessed him and he was completely healed.

And as for the years that he should live God added, fifteen more years to those years.

Blessed be the God and Father of our LORD Jesus Christ: who has blessed us with spiritual blessings and heavenly places:

According as he has chosen us in him before the foundation of the world, that we should be holy and without blame before him with love.

Having predestinated (A God given order.) us into the adoption of children by Jesus Christ to himself, according to the good pleasure of his will, to the praise of the glory of his grace, wherein he has made us acceptable in the beloved.

And whom we have redemption through the blood, the forgiveness of sins, according to the riches of his grace:

Wherein he has abounded toward us in all wisdom and prudence:

Having made known to us the mystery of his will, according to his good pleasure he purposed in himself.

That in the dispensation (before ordained) of the fullness of time he might gather together in one all things in Christ, both which are in heaven, and which are on earth: even in him:

In whom also we have obtained an inheritance being predestinated according to the purpose of him who worketh all things after the counsel of his own will:

That we should be to the praise of his glory who first trusted in Christ.

In whom ye also trusted, after that you heard the word of truth, the gospel of your salvation, in whom also, after ye believed, you were sealed with the Holy Spirit of promise. (The guaranteed Recharge)

Which is the earnest of our inheritance until redemption of the purposed possession, unto the praise of his glory.

Wherefore I also, after I heard of your faith in the LORD Jesus, and love unto all saints,

Cease not to give thanks for you, making mention to you in my prayers:

That the Lord God of our Lord Jesus Christ, the Father of glory, may give unto you the spirit of wisdom and revelation in the knowledge of him,

The eyes of your understanding being enlightened: that ye may know what is the hope of his calling and what is the richest of thee glory of his inheritance of his saints.

What is thee exceeding greatness of his power to us-ward who believe.

According to the working of his mighty power. Which he wrought (worked) in Christ, when he raised him from the dead, and set him at his own right hand in heavenly places.

Far above all principalities and powers, and might, and dominion, and every name that is named not only in this world, but also in that which is to come.

And has put all things under his feet, and gave him to be head over all things to the church.

Which is the body, the fullness of him that filleth all in all.)

For we are his workmanship, created in Christ Jesus unto good works, which God has before ordained that we should walk in them.

Wherefore I put thee in remembrance that thou stir up the gift of God, which is in thee by putting on by hands.

For God has not given us the spirit of fear: but of power, and of love, and of a sound mind.

Be not thou therefore ashamed of the testimony, of our LORD, nor of me, his prisoner, but be thou partaker of the affections of the gospel according to the power of God;

Who hath saved us, and called us with an holy calling, not according to our works, but according to his own, purpose and grace, which was given us in Christ Jesus.

But is now made manifest by the appearing of our Saviour Jesus Christ. Who hath <u>abolished death</u> (to abolish- is to counter act the force and effectiveness of by any means.) and hath brought life and immortality to light through the gospel: (We are reconnected to the vine gratified in, by Jesus Christ himself. Therefore we have been recharged by Christ.)

Wherefore I am appointed. The Bible says: But the saints of the Most High shall take the Kingdom and possess the Kingdom forever Dan 7:18.

Chapter 14

The Bible says that there is a little book: the book that John saw, which contained blessings, it gave power and authority to whomever was worthy to open it.

John records it like this;

And as John looked on, no one was able, or worthy to open the book or to even: look thereon, to reveal its contents.

The Bible says:

And I saw another mighty angel come down from heaven, clothed with a cloud and a rainbow was upon his head and his face was as if it were the sun, and his feet as pillars of fire:

And he had in his hand a little book and he sat his right foot on the earth, and cried with a loud voice, as when a lion roareth and when he had cried, seven thunders uttered their voices, and I was about to write: and I heard a voice from heaven saying unto me, "Seal up those things that the seven thunders uttered and write them not."

And the angel which I saw stand upon the sea, and upon the earth, lifted up his hand to heaven.

And swear by him that liveth forever and ever, Who created the heavens, and the things that are therein, and the earth and the things that therein are, and the sea, and the things which are therein; that there should be time no longer. (ETERNITY HAS BEGUN)

And in those days shall men seek death, and shall not find it, and shall desire to die, and death shall flee from them. Revelation 9:6

And the kings of the earth, and the great men, and the rich men, and the cheap captains, and the mighty men, and every bond man, and every free man hid themselves in the dens and in the rocks of the mountains:

And said unto the mountains, and rocks, "Fall on us and hide us from the face of him that sitteth on the throne and from the wrath of the LAMB:"

But the days of the voice of the seventh angel, when he shall begin to sound, the mystery of God, shall be finished, as he hath declared to his servants the prophets.

And the voice which I heard from heaven spake unto me again, and said, "Go and take the little book which is open in the hand of the angel which standeth upon the sea and upon the earth.

And I went to the angel, and said unto him, "Give me the little book and he said unto me, "Take it and eat it up: and it shall make thy belly bitter, but it shall be in thy mouth sweet as honey."

And I took the little book out of the angel's hand, and ate it up: And it was in my mouth sweet as honey: And as soon as I had eaten it, my belly was bitter.

And he said unto me, "Thou must prophesy again before many people, and nations: and tongues, and Kings." Revelation 21:1

And I saw a new heaven and a new earth: for the first heaven, and the first earth were passed away: And there was no more sea.

And I John saw the Holy City. New Jersusalem, Coming down from God out of heaven, prepared as a bride adorned for her husband.

And I heard a great voice out of heaven saying, "Behold, the Tabernacle of God is with men, and he will dwell with them: And they shall be his people, and God himself shall be there with them; and be there God.

And God shall wipe away all tears from their eyes; and there shall be no more death, neither sorrow, nor crying, neither shall be there any pain; for the former things are passed away!

And he that sat upon the throne said, "Behold, I make all things new!" And he said unto me, Write:

For these words are true and faithful."

And he said unto me, "It is done, I am Alpha and Omega, the Beginning and the End,

I will give unto him that is a thirst of the fountain of the water of life freely.

In the midst of the street of it, and on either side of the river there was the tree of life (AGOLLACHA) which bear twelve manner of fruits and yield her fruit every month; and the leaves of the tree were for the healing of the nation.

"Fear not; I am the first and the last:

I am he that liveth, and was dead; and, behold, I am alive for evermore, Amen; and have the keys of hell and of death.

Write the things which thou has seen, and the things which are, and the things which shall be hereafter."

Chapter 15

From henceforth let no man trouble me: for I bear in my body the mark of the LORD Jesus Christ. (I am and you should be completely recharged by the Holy Ghost)

Now unto Him that is able to do exceeding abundantly above all that we asked or think. According to the power that worketh in us.

Unto him be glory in the church by Christ Jesus throughout all ages, world without end. Amen

Believeth thou not that I am in the Father, and the Father in me? The words that I speak unto you I speak not of myself; but the Father that dwelleth in me, he does the works.

Believe me that I am in the Father and the Father in me: or else believe me for thy very works sake.

Verily, Verily, I say unto you, he that believeth on me, the works that I do shall he do also, and greater works than these shall he do: because I go unto my Father.

And whatsoever he shall ask in my name, that will I do, that the Father may be glorified in the Son.

If you shall ask anything in my name, I will do it.
If you love me keep my commandments.
But the Comforter which is the Holy Ghost, whom the Father will send in my name, he shall teach you all things, and bring all things unto your remembrance whatsoever I have said unto you.

Peace I leave with you, my peace I give unto you: not as the world giveth-give I unto you.

Not let your heart be troubled, neither let it be afraid."

It is the Spirit that quickeneth (That give you the ability to stay alive: the Holy Spirit gives life) the flesh profiteth (accomplish) nothing: <u>The words that I speak unto you, they are Spirit and they are life.</u>

<u>For I reckon that the suffering of this present time are not worthy to be compared with the glory which shall be revealed in us.</u>

For the earnest expectation of the creature, waiteth for the manifestation of the sons of God. (The creatures that are waiting: are waiting for us to accept the promises of God so that they might be delivered.

That deliverance is to bring them to repentance that they may receive Jesus as their LORD and Saviour: and be filled with the indwelling of the Holy Spirit which is being filled with love: (with GOD) God is love, so when we are filled with love we are filled with God.

The one and only thing that is able to show mercy and compassion is love.

The hand of the LORD was upon me, and he carried me out in the Spirit of the LORD, (In the Spirit of love and compassion) and set me down in the midst of the valley which was full of bones. (in the midst of a people that had no hope at all.)

And he caused me to past by them round about: and, behold, there was very many in the valley, and lo, they were very dry and he said unto me,

"Son of man can these bones live?"

and I answered, "O LORD thou knowest,"

again he said unto me, "Prophesy upon these bones, hear the word of the LORD. Thus saith the LORD GOD unto these bones;

Behold I will cause breath to enter into you. And ye shall live: and ye shall know that I am the LORD."

So I prophesied, there was a noise, and behold a shakening, and the bones came together, bone to his bone,

And when I beheld, lo, the signews and flesh came up on them and the skin covered them above: but there was no breath in them.

Then said he unto me, "Prophesy unto the wind, (command the wind to enter into them.) prophesy, son of man and say, unto the wind, "Thus saith the LORD GOD;

Come from the four winds, O breath and breathe upon these slain, that they may live,"

So I prophesied as he commanded me, and the breath came unto them, and they lived and stood up upon their feet, an exceeding great army.

Then he said unto me, "Son of man, these bones are the whole house of Israel: behold, they say, our bones are dry and our hope is lost, we are cut off for our parts.

Therefore, prophesy and say unto them,

"Thus saith the LORD GOD, Behold, O my people, I will open up your graves, and cause you to come up out of your graves, and bring you into the land of Israel.

And ye shall know that I am the LORD, when I have opened your graves, O my people, and brought you up out of your graves,

And shall put my Spirit in you, and you shall live, and I shall place you in your own land, then shall you know that, I the LORD have spoken it," saith the LORD.

Chapter 16

We have received the Holy Spirit: with power: it is time to possess the Kingdom.

For the Kingdom of God is not in word but in power.

But we have this treasure in earthen vessels, that the excellency of the power may be of God and not us.

God has given us the power to bless and not curse.

God will cause them that curse me/you, to be cursed, you are only to bless, even your enemies: yes! Your enemies. Not only bless them, but love them also.

Love is <u>power:</u> It's the only thing, that can make faith work (NO LOVE, NO POWER-KNOW LOVE, HAVE POWER. NO FAITH, NO GOD-KNOW GOD, HAVE FAITH, PLEASE GOD.)

For the Kingdom of God is not in word, but in power let God dwell in you. Your body, was made to embrace the Holy Ghost, you are his temple as he is

in this world, so are you when he indwells you, As he dwells in us we will have power.

1. POWER- To perform the will of God. With strength and courage.

2. RICHES- Wealth, virtue, excellence.

3. WISDOM- Moral insight, judgment, and understanding of what is known about God, and put into action: by you.

4. STRENGTH- The ability to have courage and face any obstacle: knowing that the power of God: is with you, never failing, being courageous.

5. HONOUR- Devine favour: displaying splendor, to light the way of life to the sinners that are out of the way.

6. GLORY- To shine in darkness, giving the light of life to unite man with the Spirit of God: to bring man to God to restore hope to them again.

7. BLESSINGS- Prosperous in every area, fortune, to give to others out of your abundance to be able to give your very best.

Jesus wants us to be spontaneous with his passion, and love of life.

We are to react with what comes natural to compassion; by God's great love and compassion for his people.

You must become an instrument that is able to be filled with love and compassion.

By which the power of the Holy Ghost operates in, it is to accomplish something for someone, that, that, person or persons cannot obtain for themselves.

Jesus came back to earth after receiving power and the Kingdom from our Father he shares his power and ability with us:

That we may be re-established on earth as intended from the beginning.

Adam and Eve gave it up: we have been given power, to take it back. I urge you, become recharged, be filled, be complete with the Holy Ghost.

Jesus died for the promise of restoration: he fulfilled his promise.

"It is finished!!!!"

Believe the gospel walk in love: live, be strong, in the Kingdom of God on earth; with power.

Thy Kingdom come on earth as it is in heaven, it is already on earth now!

Let Jesus reign:

Jesus is the orgin where ability ables, a person to accomplish and receive a decided victory: in a seemingly

impossible situation where you are able to perform and receive miracles of healings, and all kind of blessings.

For with God nothing shall be impossible.

I am apprehended: The Holy Ghost has filled my heart with the love of God, through Jesus Christ.

He said, "He that thirst and hunger after righteousness shall be filled.

I hungered and thirsted after that righteousness and the Holy Ghost has filled my heart with the love of God. He replaced my cold hard unforgiving, selfish heart with the love that I should have.

And he said as he is so am I in this world.

The kingdom of God is at my hand, and yours too, if you too put on Christ Jesus.

He has caused me to receive the gift of life and eternity, to enter there in, even when I don't fully understand it.

Yet, I was able to look forward and apprehend the promise, that I may teach others, how to enter in to the kingdom of God, and live the promise.

I have taken life into custody, by the knowledge of Jesus Christ, through the gospel.

I have that right, by my confession of faith in God, who cannot lie: believe that I am filled with the Holy Ghost which is the fullness of God.

I believe that Jesus Christ is the Son of God I believe that he died for the sin of the world, mine too; and that I have been redeemed from the hand of the enemy; and I am free from the curse and that the penalty of death

is not mine to pay, because Jesus said that he had paid the debt in full.

So who do I believe Jesus or men: I believe Jesus.

Yes I can die but I won't. I will not call Jesus a liar by giving up no matter how long the walk is.

All things are lawful unto me, but not all things are expedient: all things are lawful for me, but I will not be brought under the power of any.

What? Know ye not that your body is the temple of the Holy Ghost which is in you, which ye have of God and , and ye are not your own?

For ye (you) are bought with a price: therefore glorify God in your body, and in your spirit, which are Gods.

And what concord (agreement) hath Christ with Be li-al? or what part hath he that believeth with an infidel?

And what agreement hath the temple of God with idols? For ye are the temple of the living God; as God hath said, I will dwell in them, and walk in them; and I will be their God, and they shall be my people.

It is because of this promise I have turned from sin to live a holy and righteous life through the Holy Ghost.

Therefore I believe that I have the Holy Ghost as my guard. The bible says that if you defile this temple he will destroy you. (He's not talking about just the church but holy men and women of God who the seducers

seduce, you know looking after the holy thing with lustful eyes, to commit fornication and adultery.) So I'm protected.

I do now guard the Gospel of Jesus Christ, I do hold it unto watch, keeping watch over his word, just as he does: for him to perform it. You see he says if I ask anything in his name he will do it. Not only will he do it for me, but he will do it for you too.

I bear in my body the mark (love) of the Lord Jesus Christ.

The thing that was lost, I didn't need any how, and if I did he will replace it.

The thing that was cast in my mind that was not of God, I find is just an imagination.

By the power of the Holy Spirit it is cast down, it can not alter, or change our course; it cannot change our existence, deliverance or cancel our healing.

The Lord has already ordained your healing. Don't give up.

I tell you that any knowledge that goes against the knowledge of God has been captured and blocked from you. You are healed, by the stripes of Jesus Christ.

Sickness has no power or authority over you, you shall regain your strength, because it has been made subject to: and under your authority.

Jesus said, "Behold, I give unto you power to tread on serpents and scorpions, and over all the power of the enemy: and nothing shall by any means and hurt you."

This gift of power is able to cast down every imagination that exalteth itself against the knowledge of God.

(ALL) the total entity of what ever "that" is said to be in existence; any thing that is separated from the promises of God for his people; by his knowledge

Jesus showed us through his earthly teachings and left his word to reassure us that he has assuredly demonstrated the Fathers' will to us.

Jesus came in demonstration of the power of God.

HE never taught death; however he did show us what he thought of the dead, by raising them to life.

He never acknowledged the right of death.

(NO, NO, NO!!! death is not your friend if you are Gods' it is your enemy, and you should treat it as such.)

But instead he held death sickness and diseases captive: ultimately destroying deaths' right through his own death.

When you hold in your heart what the Holy Bible teaches about who Jesus is and what he came to do, and what we are to accomplish, you will be able to cast down every imagination that that try to exalt it self against the knowledge and power of God, every negative thought that is against what you saw Jesus do or read what he said.

You will be able to call into existence, the positive thing that will cancel all the enemies' plans, not just for you but for other too.

You will be able to leave on condition behind for another, of holiness.

The Bible says, "**Nothing** shall by any means hurt you."

Nothing: the absence of any and all units of God, is an none entity-a none sustaining existence is something that can only exist in your mind, your imagination.

Nothing: zero; does not allow addition or subtraction, zero; nothing is what it is; nothing which is subject to and under the power of another, nothing is under your power and you alone can change its out come by the Holy Ghost. Zero and zero is zero. Zero plus or times any thing is still zero.

The only time that a zero has any power is when it is subject to or behind another number that is greater than itself. If you add a number to zero it gives zero the power to change that outcome of that number added.

To God the thing that can cause you to fail under Gods' power; doesn't exist, it is an nonentity: zero: something that cannot allow change, (because you have the power over it) but is subject to and under the power of another (you), and is not able to change it's own position.

The Bible says, Behold, I have given you all power to tread on serpents and scorpions, and over all the power of the enemy: and nothing shall by any means hurt you.

Not withstanding in this rejoice not, that the spirits are subject unto you; but rather rejoice because your names are written in heaven

.

With out God we are nothing, but, with God we have all power over the enemy, of what ever the enemy thought he could do, to separate you from the love and power of God, or God from you.

Because Jesus shares his power with us.

THE END.

And for a time my pen is released
from the paper.

THANK YOU JESUS!!!!!

Forasmuch then as the children are partakers of flesh and blood, he also himself likewise took part of the same; that through death he might destroy him that had the power of death, that is, the devil;

And deliver them who through fear of death were all their life time subject to bondage.

For the kingdom of heaven is as a man traveling into a far country, who called his own servants, and delivered unto them his goods.

Wherefore thou art no more a servant, but a son; and if a son, then an heir of God through Christ.

Wherefore he saith, when he ascended upon high, he led captivity captive, and gave gifts to men.

Warnette B. Patterson